BLACK AND WHITE

WASHINGTON

TEXT: BILL HARRIS

PHOTO EDITOR: LESLIE FRATKIN

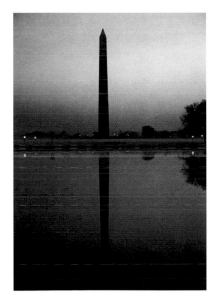

SERIES EDITOR: J. C. SUARÈS

THOMASSON-GRANT

Published by
Thomasson-Grant, Inc.

*Special thanks to
Paul Roth for additional
photo research.*

Printed in Singapore

ISBN 1-56566-070-6

01 00 99 98 97 96 95
5 4 3 2 1

Inquiries should be
directed to:
Thomasson-Grant, Inc.
One Morton Drive,
Suite 500
Charlottesville, Virginia
22903-6806
(804) 977-1780

Frontis

The construction of the Washington Monument is almost a parable about how Congress gets things done. It began with a 1783 resolution to create a memorial to the first president, but it wasn't until 1848 that a site was approved and the corner-stone laid. Work was delayed for one reason or another (none of them good), and it wasn't until 1876 that Congress appro-priated money to get on with the job. It was a 150-foot stub by then and hopelessly leaning. The aluminum capstone was finally placed at the top in 1884 and the Monument opened to the public four years later.

Facing page

Neither rain nor snow can keep bureaucrats, lobby-ists, lawgivers or anyone else in official Washington from keeping their appoint-ments. If wet pavements make the going rough, they at least inspire photogra-phers like Fred Maroon to capture the Capitol from a different perspective. And isn't it nice to know that your public servants don't use the weather as an excuse to delay getting their job done?

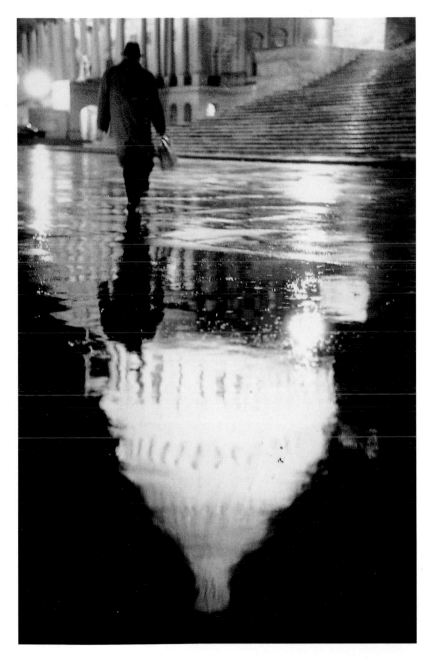

Some twenty million people visit Washington every year, and nearly all of them arrive with cameras. According to the Photo Marketing Association, more than twelve-and-a-quarter-million rolls of film are sold here in an average year. Considering that almost no one packs a camera without film, the actual number of photographs that become memories of pilgrimages to the capital city may well compete with the huge numbers that are the stock-in-trade of our representatives in Congress.

The photo albums of millions of Americans are filled with images of Washington landmarks as a recurring theme in their family history. My own family's book of memories has a section devoted to my parents' high-school class trip to Washington in 1918 and another that includes myself nearly fifty years ago carefully posed so that the tip of the Washington Monument appears as a point on top of my head. Such things were considered quite hilarious back then.

Washington's monuments and public buildings seem to most of us to have been there as long as the nation itself. But the city wasn't at all the same back in 1918, and it has changed a good deal since the 1940s. Consider the Capitol itself. It has been there since 1800, but the original was a little two-story building barely big enough for the 32 senators and 106 representatives who met there. The first dome wasn't finished for another 27 years, and it was replaced in 1863, just 36 years later. The Rotunda frieze

wasn't finished until 1953. The original artist, Constantino Brumundi, slipped from the scaffold when his work was about a third completed and died within a few weeks. His assistant finished eight more panels, but a 30-foot gap existed until Allyn Cox finished the job 65 years later. The same artist also transformed the formerly drab halls of the House wing with murals that were finished in 1972. The House chamber itself, alas, was redecorated in 1949 and is still a reminder of what was considered good taste in those days.

During the decade of the 1930's, some 800 new office buildings were added and more than 2,500 new houses. And the boom extended beyond the District's borders. Thanks to the New Deal, wage earners were able to get mortgages for new homes, and developers were more than willing to help them. Those who didn't need low-rate mortgages moved to Chevy Chase, Maryland, or McLean, Virginia.

At the same time, the government itself began moving to the suburbs. During World War II, the biggest agency of them all, the War Department, moved across the Potomac into Virginia into a pentagon-shaped building that is still right up there among the world's biggest office buildings. When the military people had begun planning their new digs, they had originally selected a site in Arlington at the end of the new bridge between the Lincoln Memorial and the Tomb of the Unknown Soldier. Sure, it would ruin one of Washington's great vistas, but there was a war on, after all. And the generals and

admirals wanted to be sure that the president and members of Congress would be reminded of their importance every time they looked out a window.

Fortunately, Washington had a Planning Commission, one of the country's first, and it convinced the brass that war or no war, they could get their work done just as efficiently a bit further down the river.

That powerful commission had it beginnings in 1871 when Alexander Shepherd was put in charge of turning a sleepy Southern town into a city worthy of a great nation. His accomplishments in just three years were astounding. But 29 years later, the Mall still didn't measure up to the original grand plan envisioned by Pierre Charles L'Enfant, who had designed an elegant "Federal City" back in 1791. The best architects of the day, Daniel Burnham of Chicago and Charles McKim of New York, were called in to bring the plan into the 20th century and to create the "City Beautiful." What we see, and photograph, in Washington today is largely the result of their work. The commission that hired them, headed by Michigan's Senator James McMillan, was succeeded by the Fine Arts Commission, which is still implementing the plan initiated in 1900.

Compared to many of the other world capitals — London, Paris, Vienna — Washington is a bit of an upstart. But by world standards, the United States is still a young country, and what has been accomplished in making its capital such a striking and

memorable place is nothing short of remarkable. Even more so when you consider that what has been done here has been done by consensus. No autocrat has ever been able to say "build it here," or "build it in this style." It is as perfect a tribute to democracy as anything ever built in marble and stone.

Washington has another advantage over other capital cities: Government is its only business. Its only export is waste paper. But that wasn't part of the original plan. When L'Enfant presented his dream to Congress, they bought it because of the arithmetic involved. His original city plan covered 6,611 acres, and only 541 of them would be covered by public buildings. He dedicated 3,600 acres for streets, avenues and squares, and that left 2,470 that could be sold off as commercial property. Since it was all federal land, the government was entitled to share half the proceeds with the original owners. And that appealed to members of Congress, who had appropriated $66 an acre for the site and knew that once they moved into the neighborhood, values would skyrocket.

They did. But the value of Washington, D.C., can never be measured in dollars. Regardless of their politics, most Americans consider this city to be a shrine to what their country has accomplished and what it will be when their grandchildren arrive here, cameras in hand, to celebrate this place that is something much more than the "City Beautiful."

<div align="right">BILL HARRIS</div>

Facing page

Washington National Airport is unique for an American city because it is less than four miles from the center of town. The site was chosen by congressional committees, who might be accused of being self-serving since congressmen are champion frequent fliers. The land was 90 percent underwater, and before the airport officially opened in 1941, 4,500 WPA workers spent nearly four years filling the 750 acres and building more than two miles of levees to make sure the landfill wouldn't wash away.

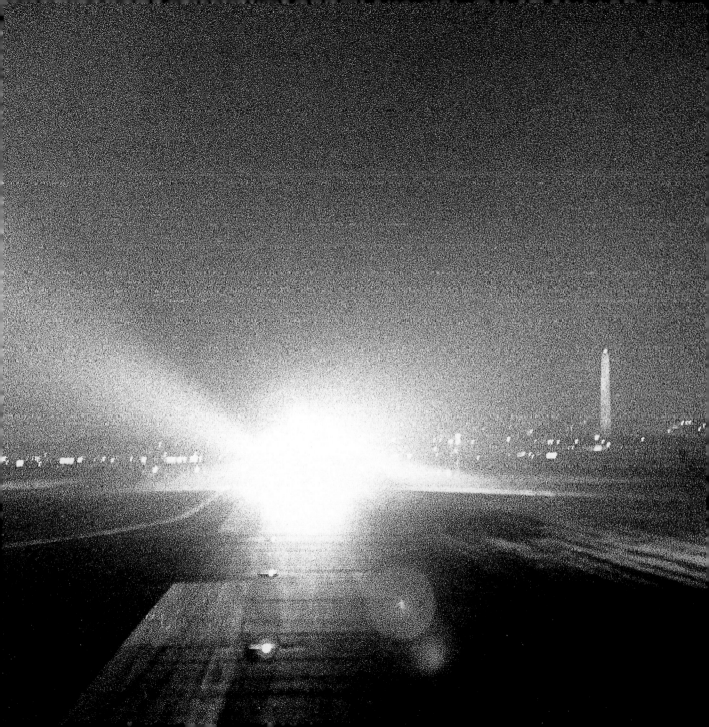

Right

When the Chesapeake and Ohio Canal was dug in 1828, its builders said it would make Washington a major industrial center. Things turned out differently when the Baltimore and Ohio Railroad, built at the same time, took business elsewhere. After the last coal-filled barge floated past Georgetown in 1924, the canal seemed doomed to the dustpile of history. Fortunately, 184 miles have been restored and the C&O Canal today is a peaceful oasis.

Facing page

The spires of Georgetown University, the Potomac Boat Club and a racing scull powered by strong arms in Fred Maroon's photograph seem to be from another era. But the sport of rowing is a long-standing Washington tradition, as important on the Potomac today as it ever was on the Thames in England. The Boat Club sponsors three important regattas every year.

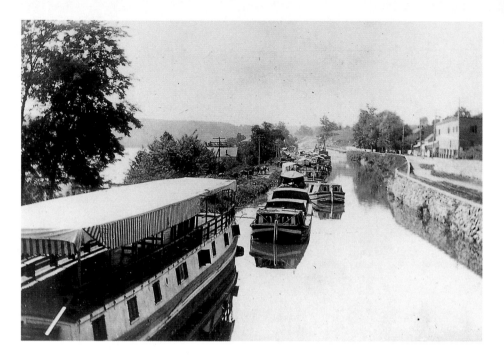

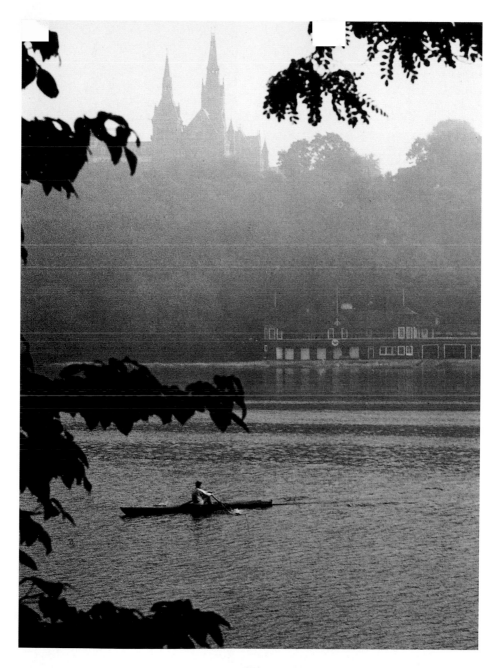

When Captain John Smith explored the Potomac in 1608, he reported that it was alive with fish—so many, in fact, that you could catch them with a frying pan. The fishing is still good here, but these youngsters spotted on the riverbank by Darrow Montgomery didn't think to bring a frying pan with them. In fact, they seem to have brought a picnic lunch rather than relying on fisherman's luck to provide their next meal.

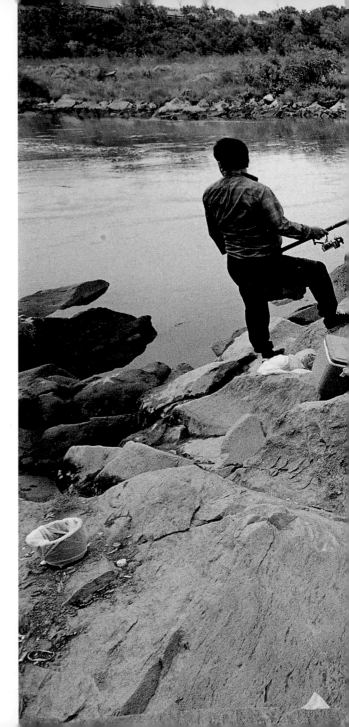

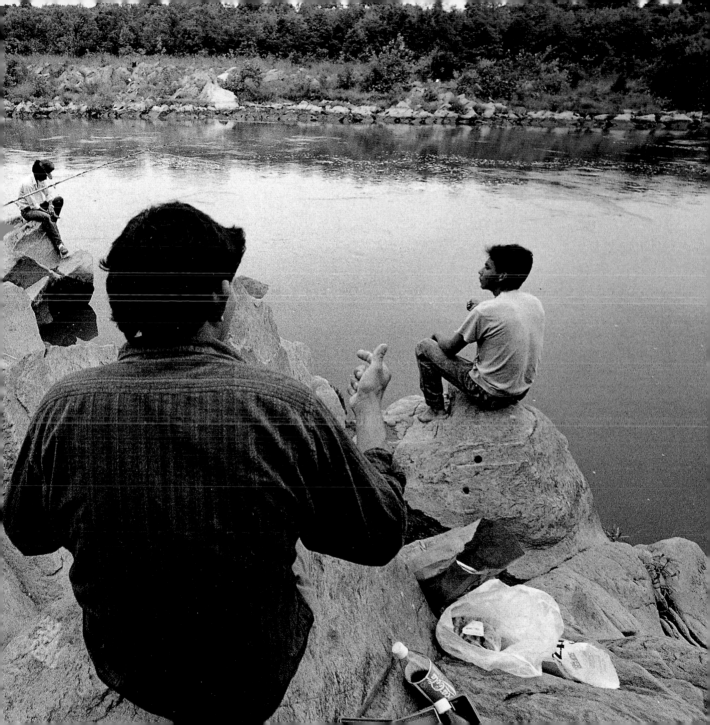

Until the early 1800's, when Falls Bridge was built at Georgetown, the only way to cross the Potomac was by ferry. That bridge was washed away and replaced by a sturdier one supported by chains that became the gateway to Virginia for Federal troops in the Civil War. Among those who crossed it was Thaddeus Lowe, chief of the corps of aeronautics of the U.S. Army, who had an observation balloon in tow and had to use the trestle-work rather than the roadway, a crossing he described as "novel, exciting and not a little dangerous."

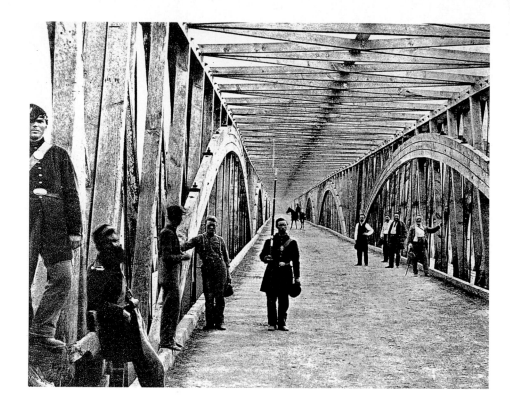

Facing page

By the time Ulysses S. Grant moved into the White House in 1869, there was talk of moving the capital. It was clearly time to clean up the city, and Grant gave Alexander Shepherd power to create parks, pave streets and remove eyesores. He succeeded admirably, but let the Pennsylvania Railroad build a terminal on the Mall with tracks crossing it and running down local streets. They weren't removed until 1907 when Union Station was built, but some neighborhoods still rang with the huffing and puffing of steam engines like this one at the B&O roundhouse at Twelfth Street and Massachusetts Avenue well into the 1940's.

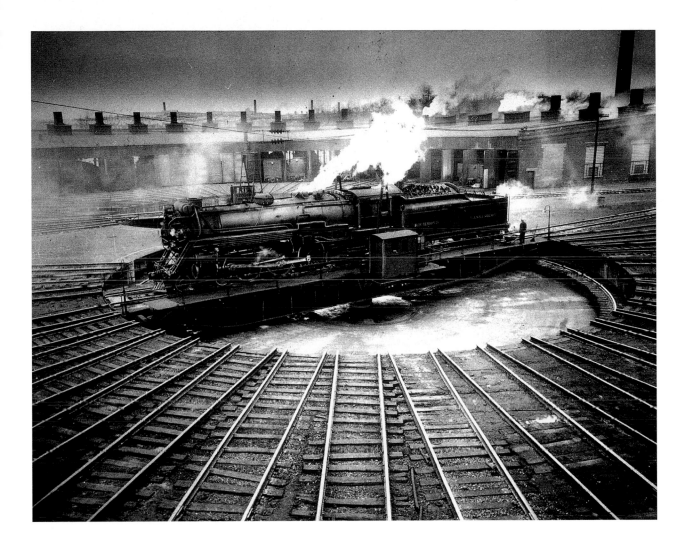

The pyramid-topped Post Office Building, built in 1899 on Pennsylvania Avenue, was the centerpiece of Washington's old "downtown," most of which has long since given way to more modern, and far less charming buildings. The Post Office tower received a death notice in the 1920's when plans were announced for the Federal Triangle. It was considered far too tall, and it blocked a complex of low-level buildings around a plaza on the very corner where it stood. It was still there in the 1960's when President Kennedy's Pennsylvania Avenue Commission recommended saving the tower as a memento of earlier times. They proposed removing the main structure itself, but thankfully that proposal was forgotten, too.

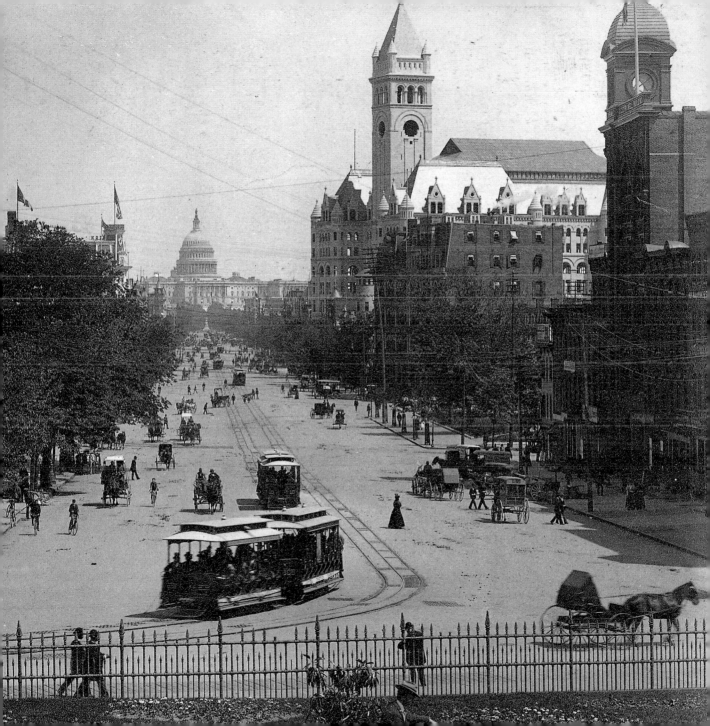

In 1910, when Lewis Hine joined the staff of the National Child Labor Committee, there were more than twenty million children under the age of 16 in the work force. His photographs, more than 5,000 of them, did more than the millions of words the committee generated to change public opinion about their plight. Among his work was this image of a seven-year-old newsboy who, according to Hine, "tried to shortchange me when he sold me a paper."

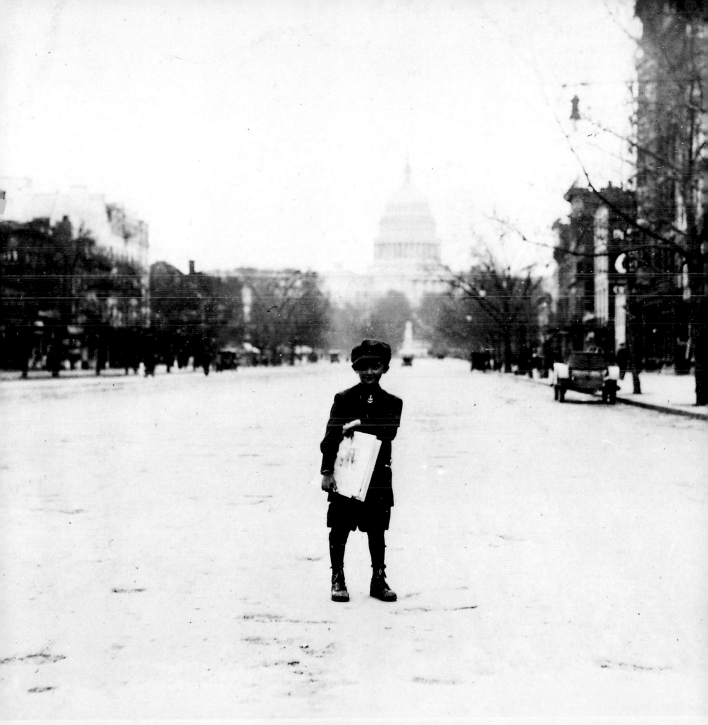

James Smithson had never been to the United States, but he left his entire fortune — $541,379.63 — to create an establishment in Washington "for the increase and diffusion of knowledge." Congress debated for eight years whether to accept the gift. Smithson was not only a foreigner, but the illegitimate son of an English duke. When they finally agreed in 1846, James Renwick designed the Romanesque "castle" on the Mall that is the symbol of the Smithsonian Institution. Its collection has well over 78 million items and its various museums attract twice as many visitors each year as Disney World.

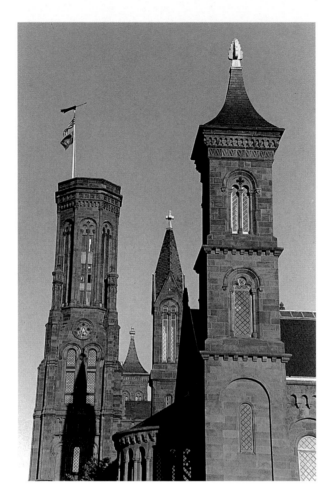

Facing page

Ever since Theodore Roosevelt laid the cornerstone of the Episcopalian Cathedral Church of St. Peter and St. Paul in 1907, work has never stopped on the imposing edifice, more commonly called the National Cathedral. Except for the Cathedral of St. John the Divine in New York City, also unfinished, it is America's largest house of worship. The original design was by Dr. George Bodley, working in England, and Henry Vaughn, working in the United States. On the theory that one head was better than two — especially two separated by so many miles — the design was eventually turned over to Philip Frohman, a local architect, in 1919.

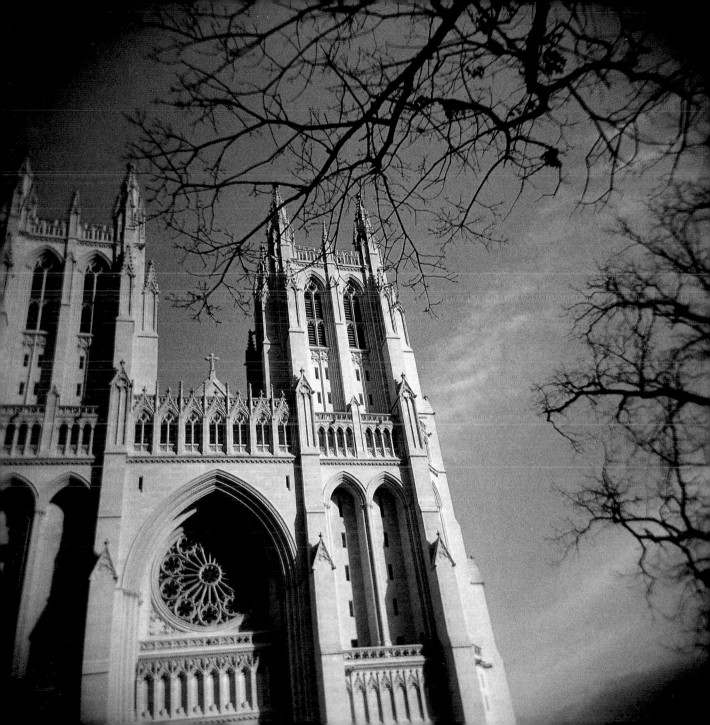

Facing page

Cass Gilbert, the architect of the Supreme Court Building, said his goal had been to create "a building of dignity and importance suitable for its use as the permanent home of the Supreme Court of the United States." Mr. Gilbert was better at expressing himself in classical buildings than words, but Justice Louis Brandeis thought he was deficient even at that. The judge refused to move his office there when the building was completed in 1935. It was too massive, he said, and not at all a reflection of the humility he felt was key to the job of a Supreme Court Justice.

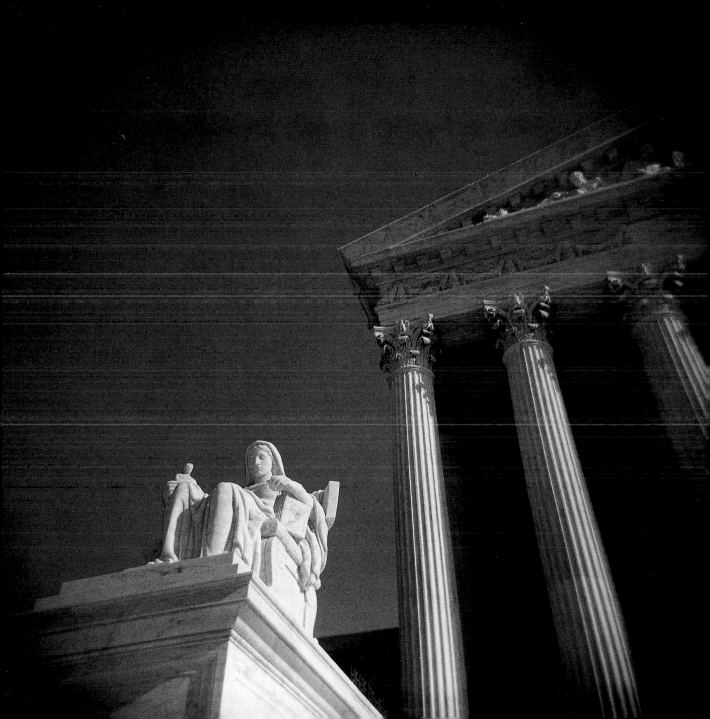

Facing page

Toni Frissell, a photojournalist working in Europe in the 1940's, counted among her subjects no less than Winston Churchill and Pope Pius XII. At home in Washington, though, she was best-known as a fashion photographer. Part of the reason was the city itself. Washington's buildings and monuments were an important part of her fashion statements. As one admirer pithily summed up her work, "She placed models in monumental contexts."

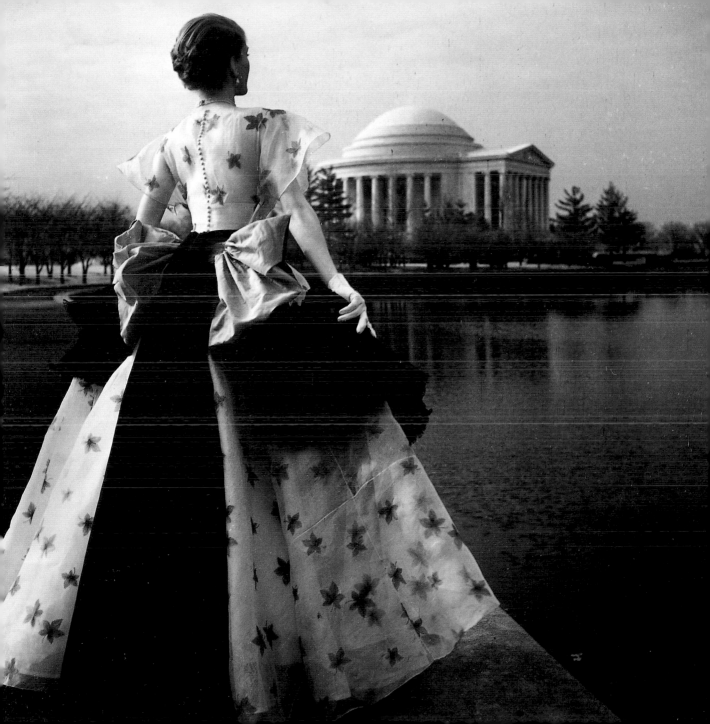

You could go to Rome to see the ruins of the Baths of Diocletian, but Washington's Union Station, inspired by the original, can give you a better idea of what it was like when the Emperor actually bathed there. Among the classical details are these figures, captured by Tillman Crane, waiting to extend a warm welcome to Amtrak passengers arriving to marvel at the city's other wonders.

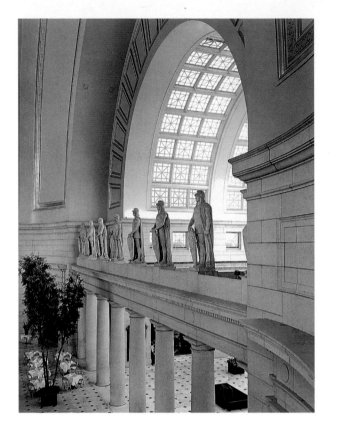

Facing page
The Arlington Memorial Bridge, opened in 1932, was designed by the celebrated architectural firm of McKim, Mead and White. Their devotion to the beaux arts tradition carries the classical feel of Washington across the Potomac to Arlington, Virginia. Charles McKim was brought to Washington along with Chicago architect Daniel Burnham in 1901 by a commission, headed by Senator James McMillan, charged with turning DC into the "City Beautiful." The commission's work led to the creation of the Mall, of Union Station, and much of everything beautiful in between — including Memorial Bridge.

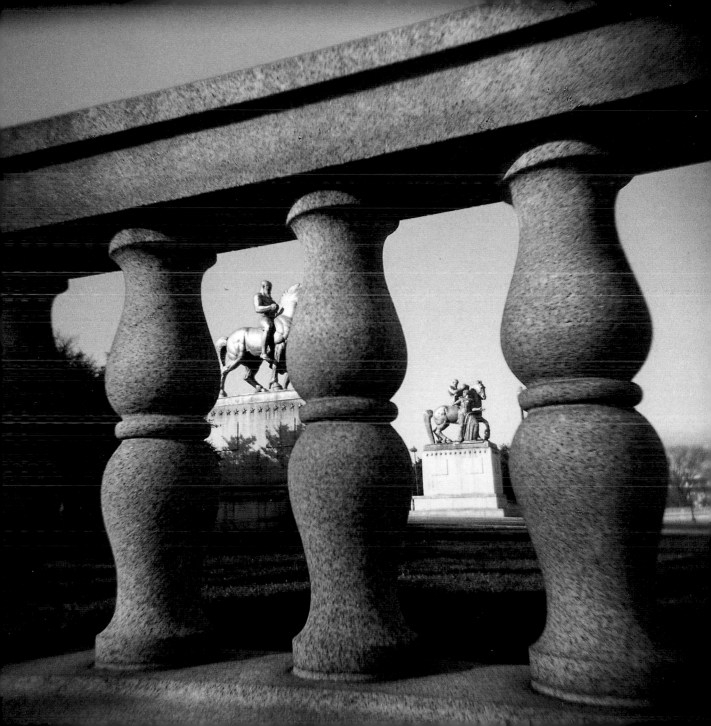

Almost nothing happens in Washington that isn't controversial. When the plan for the Jefferson Memorial was announced in 1934, it called for removal of many of the cherry trees along the Tidal Basin, and protesters chained themselves to the trees to save them. The plan also called for the statue to depict Jefferson in a Roman toga, and protesters showed up to disabuse architect John Russell Pope of such an un-American idea. The trees lost, but the fashion statement was changed and Jefferson is dressed in a fur-trimmed topcoat. The original coat was Polish, a gift to the third president from General Thaddeus Kosciusko.

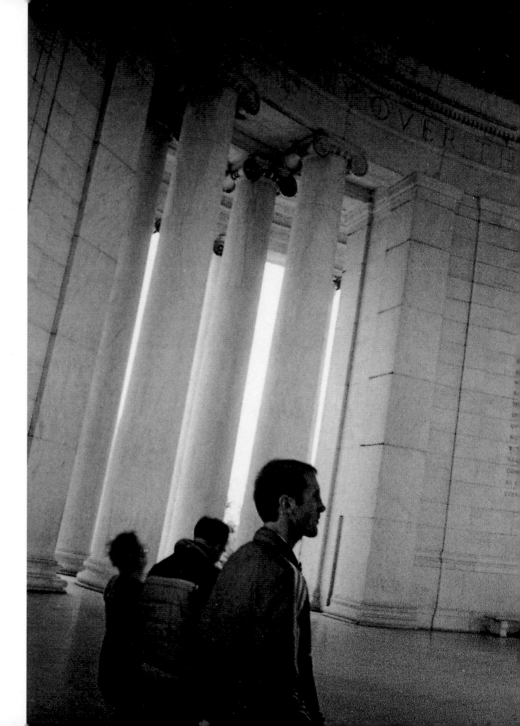

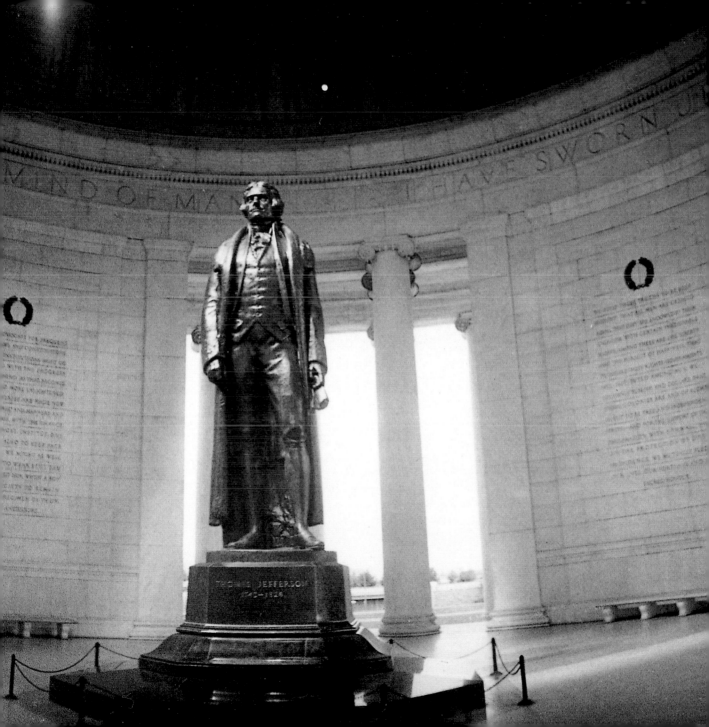

Special lighting in the Lincoln Memorial ensures that the effect of light and shadow on Daniel Chester French's monumental sculpture never changes and is always dramatic. The shadows cast by litter on the floor are constantly chased away by Parks Department people who work to make sure that the monument itself is maintained in the same pristine condition as the day it was dedicated by President Warren G. Harding in 1922.

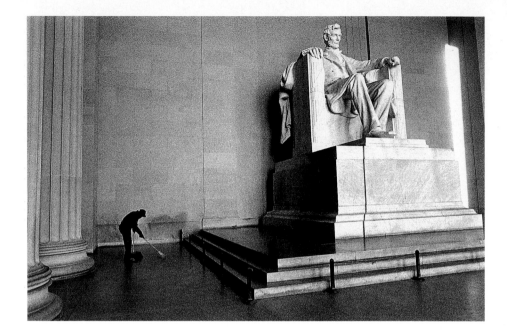

Facing page
During his forty years as a *New York Times* photographer, George Tames chronicled nine presidents, from Harry Truman to George Bush. President Eisenhower chose two of his photographs as official portraits and a third became a six-cent Eisenhower postage stamp. But Tames didn't limit himself to living presidents. This 1960 still-life of the Lincoln Memorial is one of his most memorable images. He called it, simply, "In Reverence."

Following pages
Mr. Lincoln gets a thorough scrubbing twice a year, and in the meantime the massive sculpture is kept free of dust and cobwebs by Parks Department workers such as James Hudson, whose job it is to keep the 16th president as shiny as a new penny. The effort is especially important because of exhaust from cars and airplanes. As a restoration expert explained, the Lincoln Memorial is "like a giant Alka-Seltzer tablet. You can almost hear it fizz when it rains."

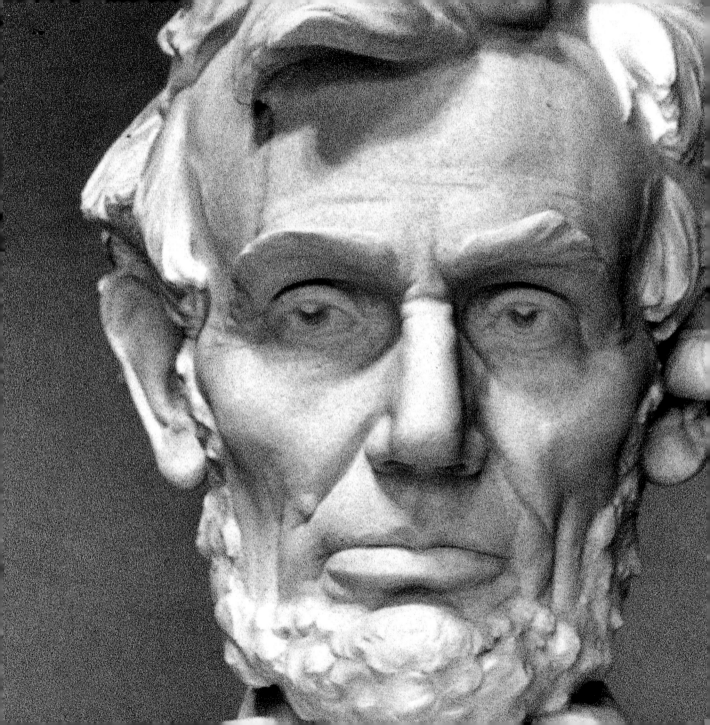

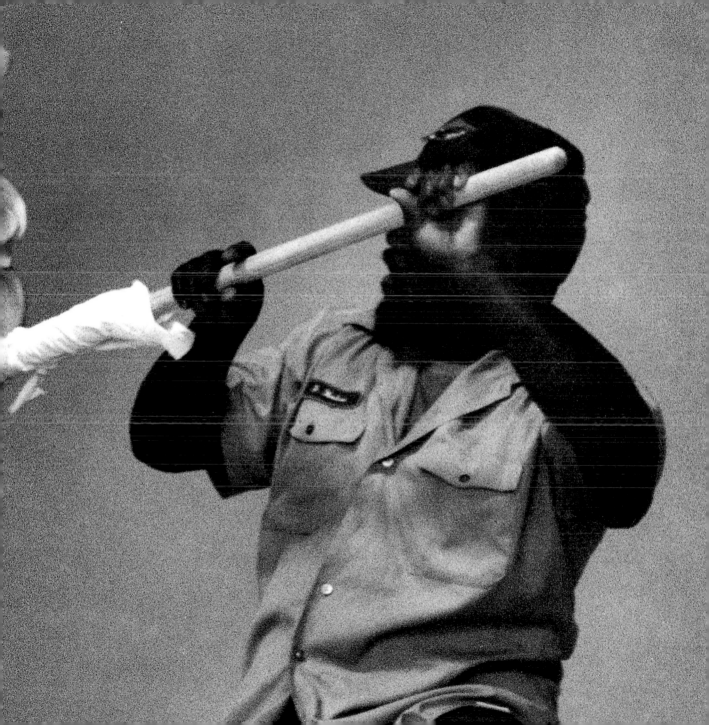

The National Gallery of Art, opened in 1941, is old by Washington museum standards, but a newcomer compared to similar institutions in other cities. It was built by financier and philanthropist Andrew Mellon, who gave the Gallery its first eleven paintings, five of which he had bought from Soviet officials who had lifted them from the Czar's collection at the Hermitage. The new East Building, designed by I.M. Pei and photographed by Steven Puglia, was added in 1978. Its pink marble triangles might have been in the back of Pei's mind when he later designed his controversial glass pyramid for the Louvre in Paris.

The clock tower of the Old Post Office Building on Pennsylvania Avenue at Twelfth Street, seen here in a behind-the-scenes view by Rosalind Solomon, has been reminding Washingtonians that time flies since 1899, when architect W. Edbrook added the Richardson Romanesque structure to the Washington skyline.

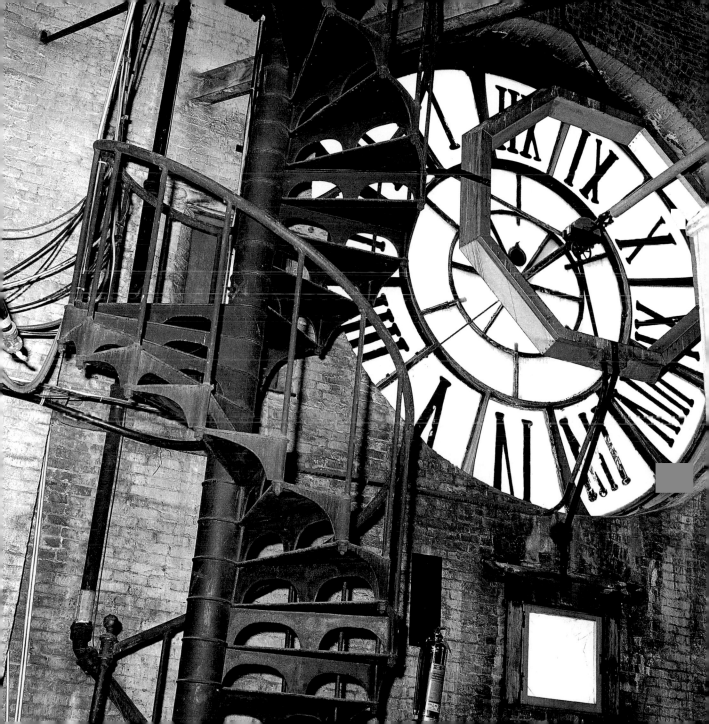

The giant pandas Ling-Ling and Hsing-Hsing (pronounced shing-shing) arrived at the National Zoo in 1972, a gift from the People's Republic of China. Several attempts were made to mate the pair, and although Ling-Ling gave birth to five cubs, including a pair of twins, none lived more than four days. Ling-Ling herself died in 1992, leaving Hsing-Hsing the only living panda in the United States. There are 16 pandas in zoos outside China, and 90 in the People's Republic itself, including a mere 11 born in captivity.

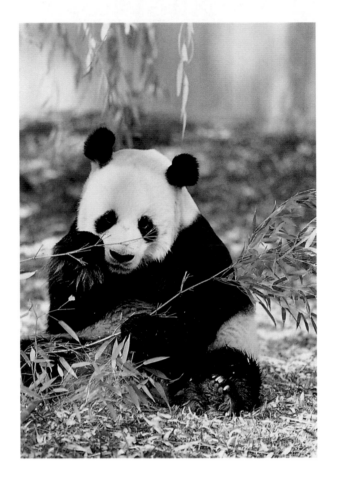

Facing page
The National Zoological Park is one of the dozens of arms of the Smithsonian Institution. It has more than 2,400 animals representing 650 species, about 30 of which are nearly extinct in the wild. In addition to its famous panda, the zoo also has rare white tigers, descendants of Mohini, the first white tiger in the Western Hemisphere, who arrived from India in 1960. The pond that is home to rare water birds is also a favorite haunt of migrating birds who, like other visitors to Washington, find it a perfect place to unwind after a long trip.

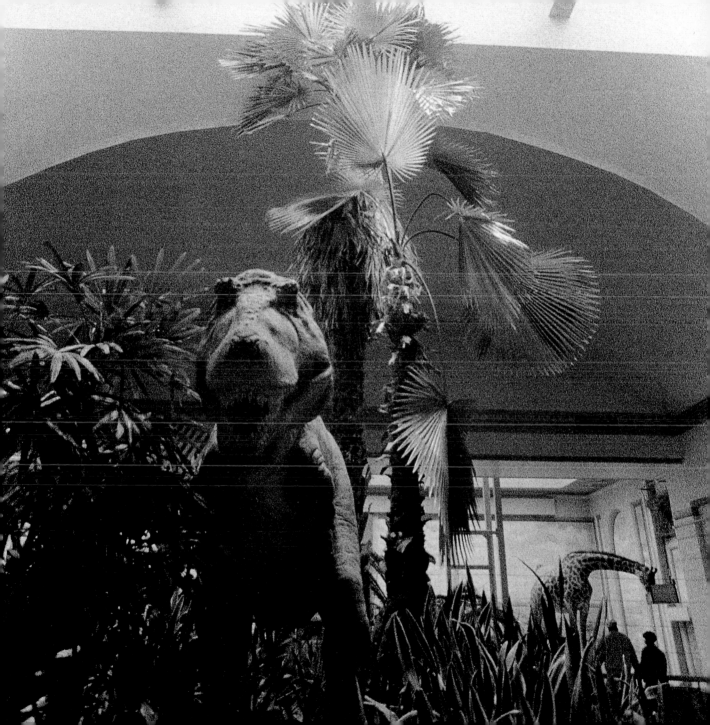

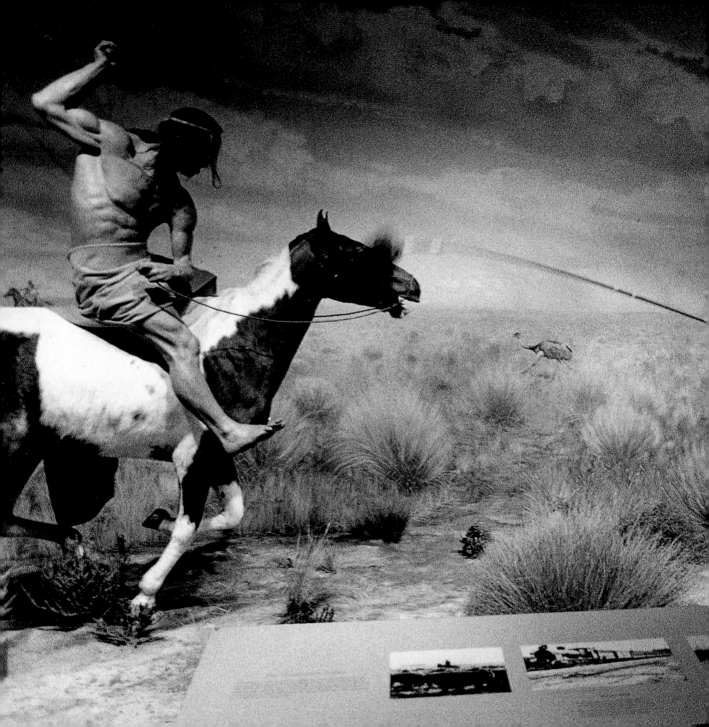

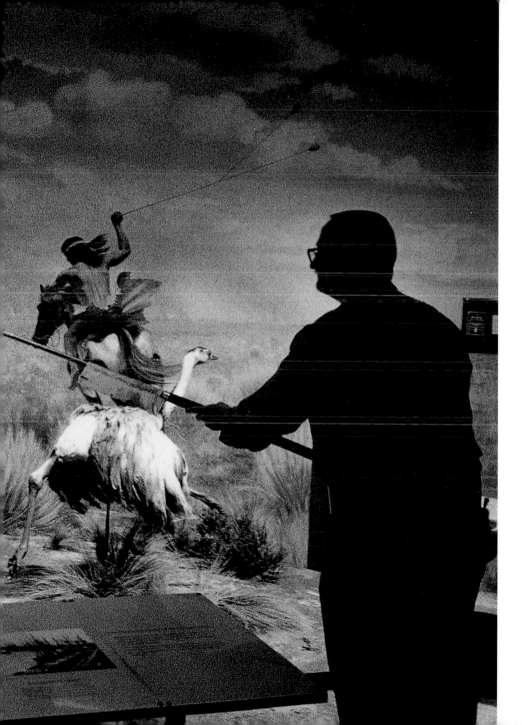

The National Museum of Natural History has several life-size dioramas among treasures ranging from the Hope Diamond to an insect zoo. The institution is filled with dinosaur bones, trophies from Teddy Roosevelt's safaris, priceless artwork and much more. Keeping it all from getting dusty is a daily chore, but the biggest challenge is cleaning those dioramas without leaving footprints. Darrow Montgomery discovered their secret, and thanks to his camera, now you know how they do it.

A time traveler might find this spot confusing. It was originally an apple orchard, then a farmer's market. It eventually became known as "President's Square," but when the Marquis de Lafayette visited in 1824, it was renamed for him. You might ask, if it is Lafayette Square, why is its centerpiece a statue of Andrew Jackson? The hero of the Battle of New Orleans once lived here and, of course, in the White House across the street. When asked to create America's first equestrian statue, sculptor Clark Mills refused because he had never seen either Jackson or a statue of a man on a horse. After relenting, he executed the job and even sold a duplicate of the work to the City of New Orleans.

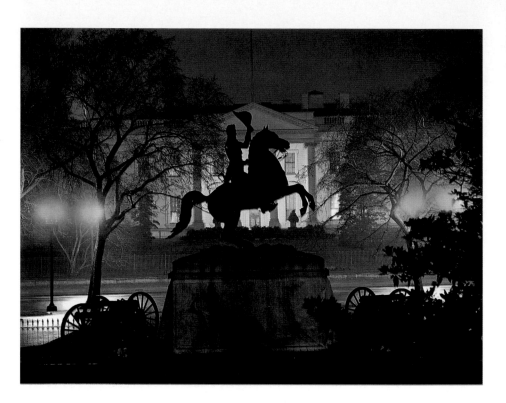

Facing page

In the years before World War II, the White House gate was generally open and visitors could stroll up to the door, which would be answered by a butler who extended a silver tray to accept a calling card. It was usually enough to gain admittance. These days, security has moved back to the gate, photographed one snowy day by Rosalind Solomon, but the guards are as unobtrusive as gardeners.

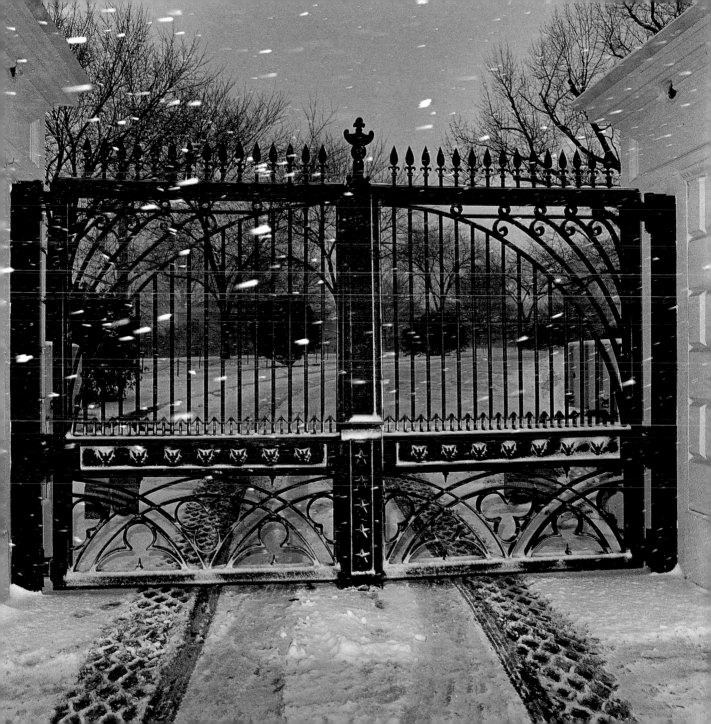

During the Civil War, young men from every state north of the Mason-Dixon Line got their first look at the nation's capital, as did scores of European military men brought here to turn them into soldiers. Into the mix one day arrived this delegation of Native Americans from the West, possibly relieved that the white men were fighting each other and not them. Their day would come.

Facing page

On June 14, 1906, a daredevil named Lincoln Beachy circled the top of the Washington Monument dangling beneath a motorized gas bag, and the age of flight descended on the District of Columbia. He eventually landed on the White House lawn, creating a tradition that was reversed in 1911 when Harry Atwood took off from there in a Wright Type E biplane, nearly taking the flagpole of the Executive Mansion with him.

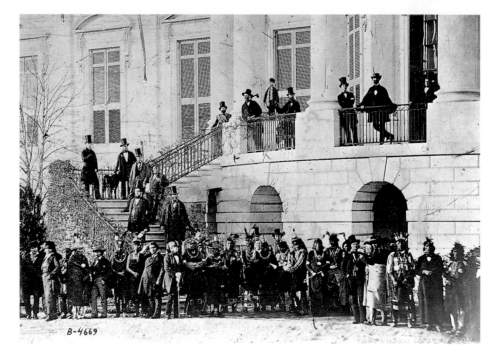

B-4669

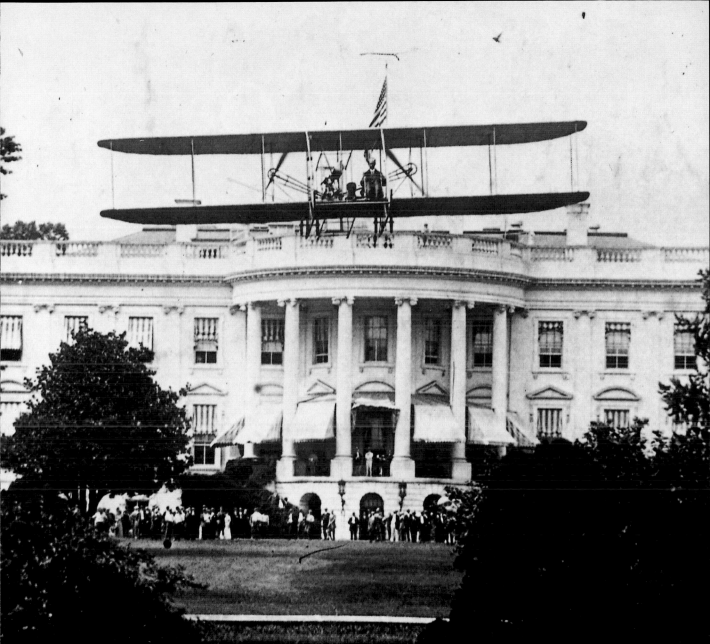

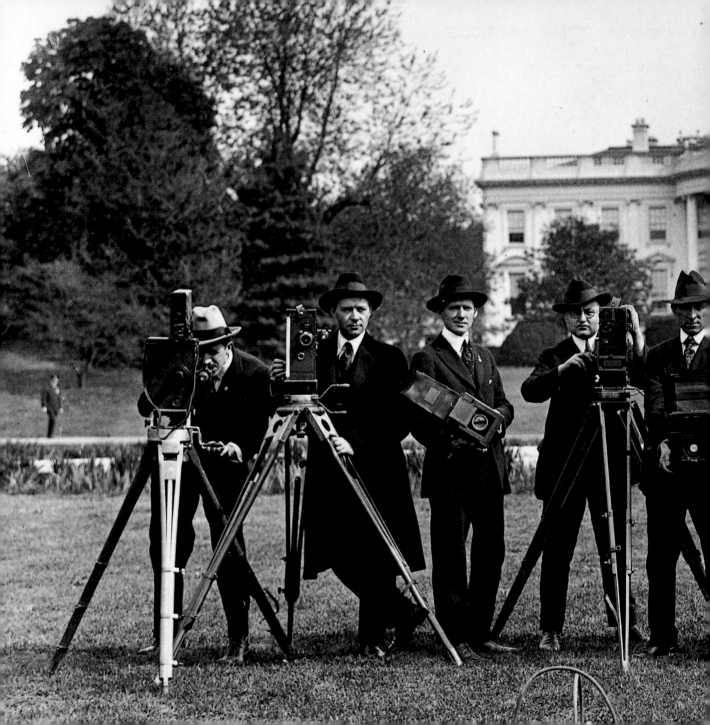

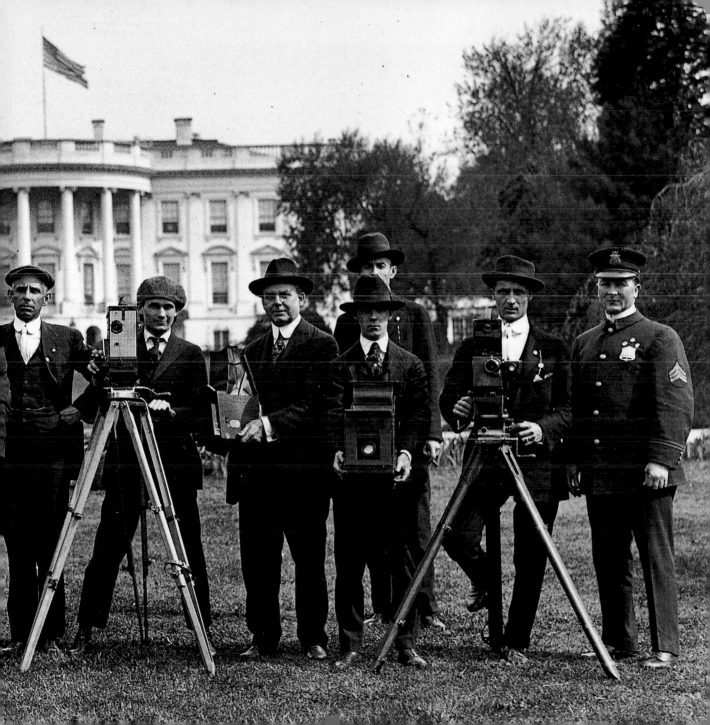

Previous pages
There are far more camera-men in Washington than there are congressmen.
But back in 1919, when these photographers posed in front of the White House, the ratio was much closer. It was significant that their backs were to the building, whose grounds had been closed during World War I and did not reopen until after it ended. President Wilson was away during most of 1919, and when he returned, his illness kept the Executive Mansion off limits to press and public alike.

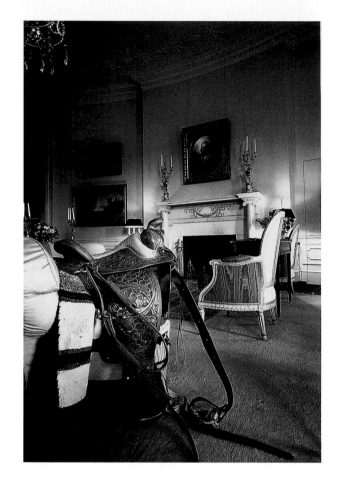

Left
When Lyndon Johnson moved into the White House, he brought his western-style saddle with him, adding an unusual touch to the classic formality of the second-floor living quarters. Many other presidents were horsemen, but possibly the most unlikely was the 300-pound William Howard Taft. When he once told an associate he had just taken a 25-mile horseback ride and felt terrific, the man shot back, "How's the horse?"

Facing page
After the 1932 election, Eleanor Roosevelt said, "I never wanted to be a President's wife, and I don't want to be one now." But she became the most prominent First Lady of them all. During the Depression and beyond, almost as much mail crossed her desk here in the White House as did FDR's in the opposite wing.

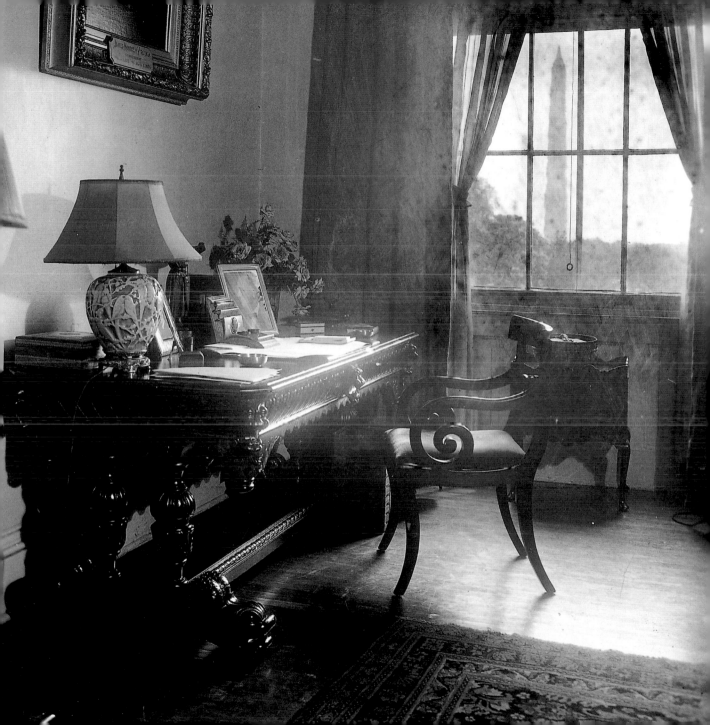

The Occidental Grill, next to the Willard Hotel, is filled to the rafters with black-and-white photographs of the great, near-great, well-remembered and long-forgotten players on the Washington scene, some of whom have been rephotographed by Leslie Fratkin. Writing in *The New York Times*, Maureen Dowd, who described the Occidental as an "archaeological site," said that it is "a rather fine spokesplace for the city. Too many gimlets and the world blurs into a bureaucracy."

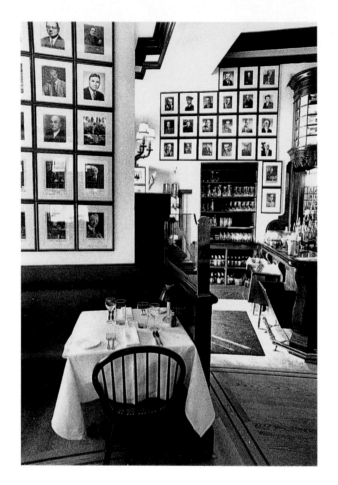

Facing page
Political science is the discipline most often associated with Washington, but there is a large scientific community here, too, and in 1878 they got together to form the Cosmos Club. A few years later they moved into this building, where Leslie Fratkin found two members in a serious game of chess. The clubhouse is 60 years older than the club. It was here that Dolley Madison entertained after she was widowed, and during the Civil War it was headquarters for George B. McClellan's Army of the Potomac.

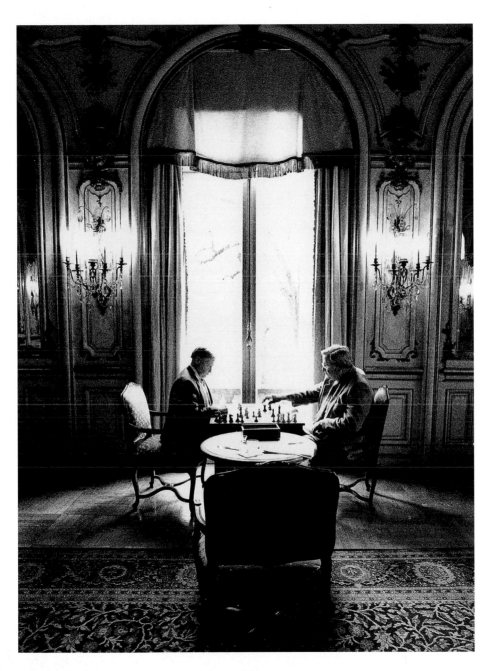

At the time it was built, the Washington Monument was the world's tallest structure, and, at 555 feet, 5 1/8 inches, it is still the tallest masonry tower. No one gave any thought to cleaning it until 1934 when the PWA took on the job, with men working for five months scrubbing the marble with wire brushes. At one point during the operation, a person or persons unknown scaled the scaffolding and made off with the platinum-tipped lightning rods from the top.

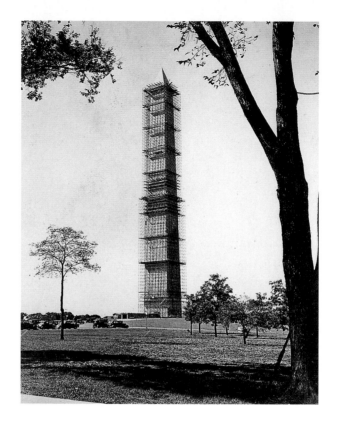

Facing page
In the 1930's, Washington's commissioner of public grounds decreed that blacks could use the ballfields and tennis courts on the Ellipse and the golf course in East Potomac Park only on Tuesdays. He also segregated Rock Creek Park, and not an eyebrow was raised. But when he barred blacks from the bathing beach at the Tidal Basin, Congressman Martin Madden cut off funds and ordered the beach closed. It was the first time equal rights for blacks created a stir in the District of Columbia.

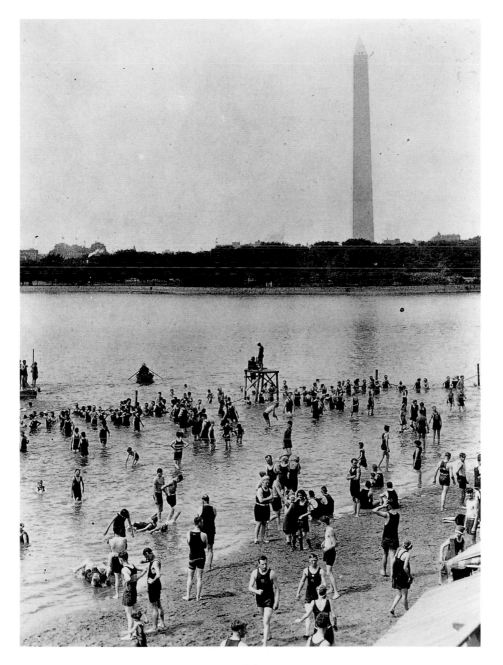

51

Volkmar Wentzel's classic nighttime shot of the Washington Monument and the Capitol dome was taken from between two of the 36 columns of the Lincoln Memorial, which was placed at the west end of the Mall as a counterbalance to the Capitol at the other end. Until 1922, when Henry Bacon's Greek temple memorializing Abraham Lincoln was built, the site had been a swamp.

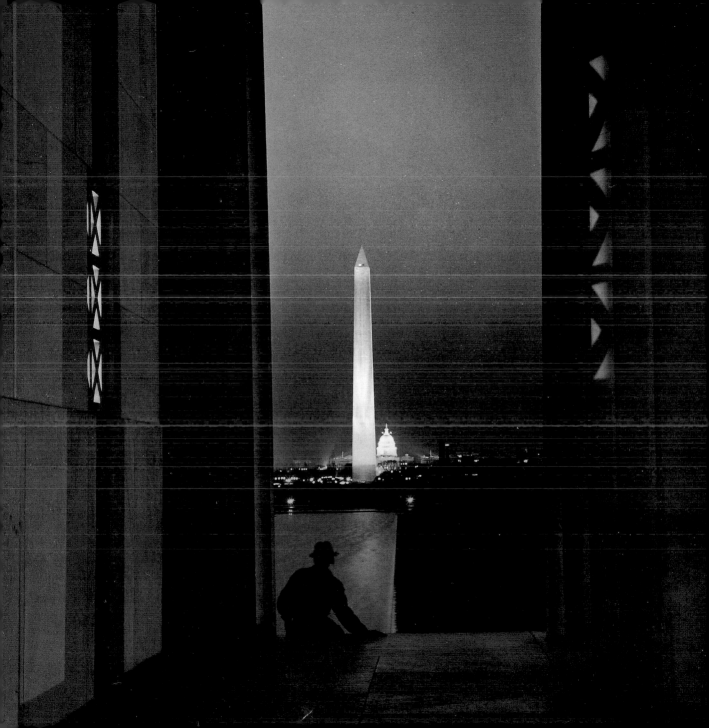

Previous pages

When the first plans were drawn for the Washington Monument, they included a massive Greek temple at its base. Once the foundation of the obelisk was in place, construction ground to a halt for forty years or so, during which time the stump began to sink into the soft ground. The problem led to the abandonment of the temple idea, and today the base is a triumph of modern simplicity. You can only get to the top of the monument by elevator, a trip that takes a little more than a minute. But you can walk down the stairs. Be warned, though: There are 898 steps, and even with gravity on your side, it can be a tiring experience.

Facing page

One of the things that strikes first-time visitors to Washington is that trees are such an integral part of the skyline. Looking across the Potomac from Virginia, the vista is of towers and spires rising above the treetops — although many of the buildings are hidden behind a mass of green. Among the exceptions is the dome of the Capitol. Depending on your point of view, even it sometimes seems to be lost in a forest grove.

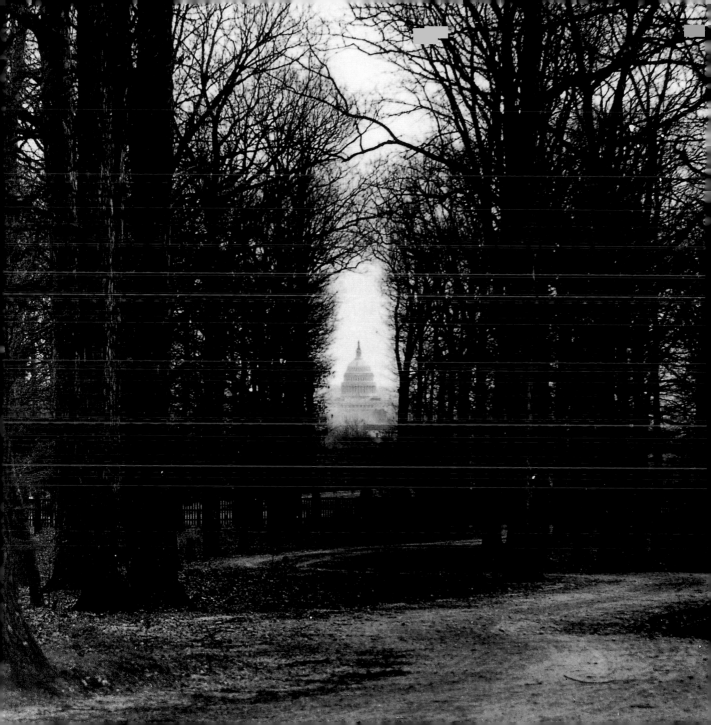

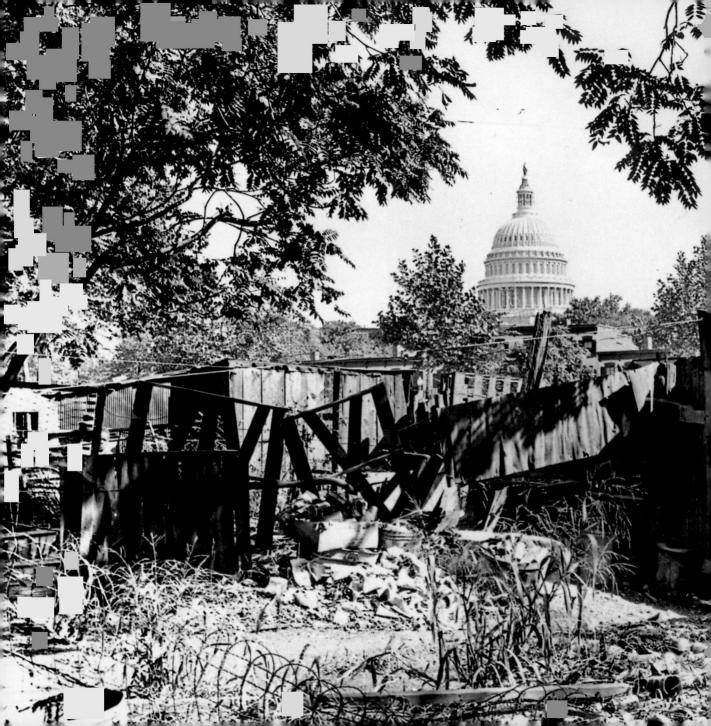

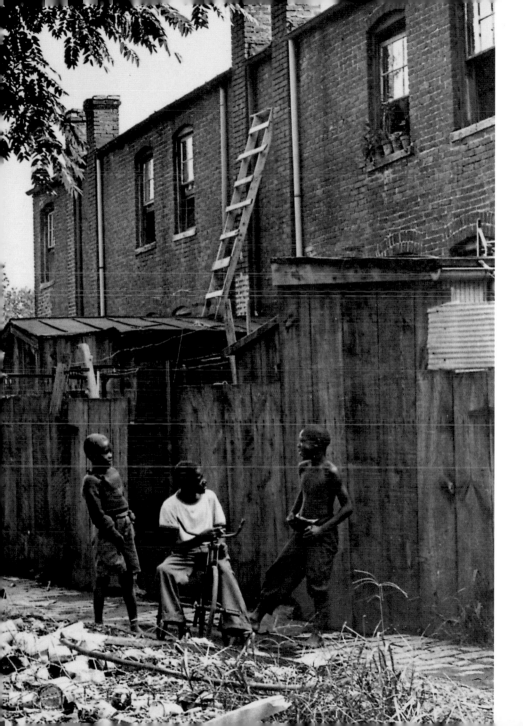

Slums are a fact of life in every city, but Washington had an embarrassment of them until well after World War II. The impetus to begin removing them came from photographs like this one that the wire services spread across the country and around the world in the 1940's and '50's. More often than not, they were published with a caption headed, "The Washington Sightseers Never See."

Facing page

Americans began regarding Washington as a vacation destination during the 1890's. But not everyone was a simple sightseer. Their numbers included thrill-seekers given to such publicity stunts as riding high-wheeled bicycles down the Capitol steps. Such things prompted President William Howard Taft to wonder what would become of the presidency now that a major part of the job was luring tourists to town.

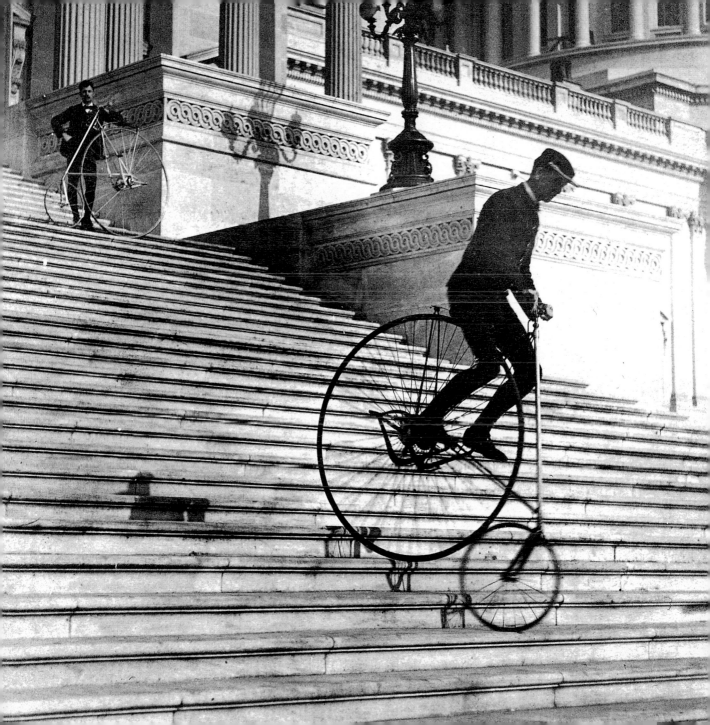

On November 26,1963, the
flag-draped coffin of Presi-
dent John F. Kennedy was
taken from the White
House to the Capitol
Rotunda, where it was
placed on the catafalque
that had held the body of
Abraham Lincoln on this
same spot. Fred Maroon
captured the scene as peo-
ple from every walk of life
filed past to pay their last
respects to the fallen presi-
dent. A local cab driver
remembered that what
impressed him most was
the silence. "All these
thousand of people," he
said, "but you could hear a
pin drop."

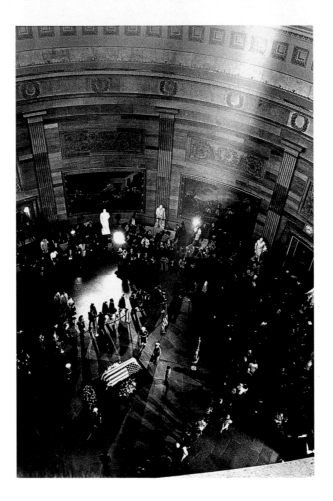

Facing page
The Capitol Rotunda is 180
feet from the floor to the
canopy, captured here by
Craig Sterling. The fresco
that embellishes it is by an
Italian immigrant, Con-
stantino Brumundi. The
cast-iron dome that enclos-
es it replaced the original
copper-sheathed wooden
dome, designed by archi-
tect Charles Bulfinch, that
was removed in 1855.

Following pages
Washington nightlife runs
the gamut from jazz clubs
to discos to cafés to
classical music and theater.
No taste goes unsatisfied
after sunset in this town.
But as Craig Sterling's view
of the Mall at night sug-
gests, the city itself is a joy
to behold after dark. And
there are few pleasures in
Washington that quite
match standing on the Capi-
tol Building's terrace at
dusk with the whole city at
your feet, watching the
lights come on along the
streets and on the Wash-
ington Monument off in the
distance.

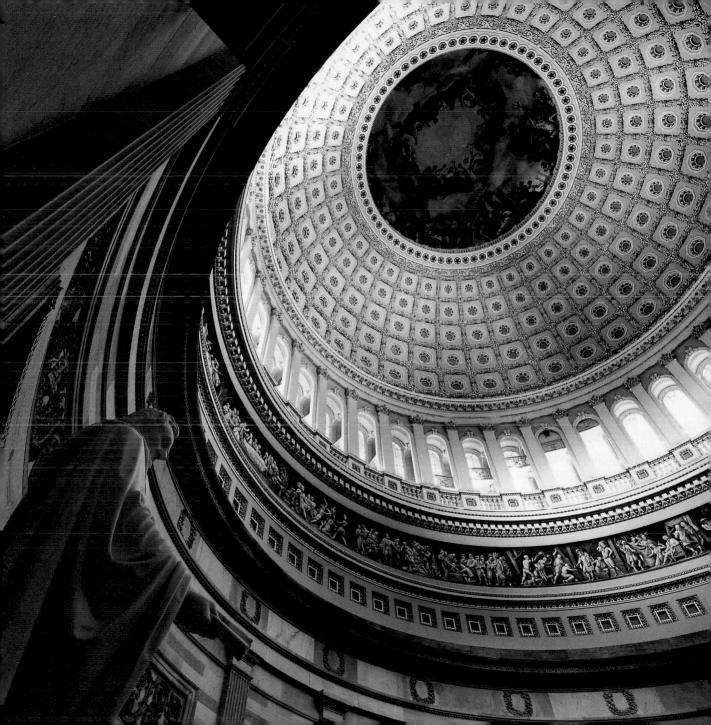

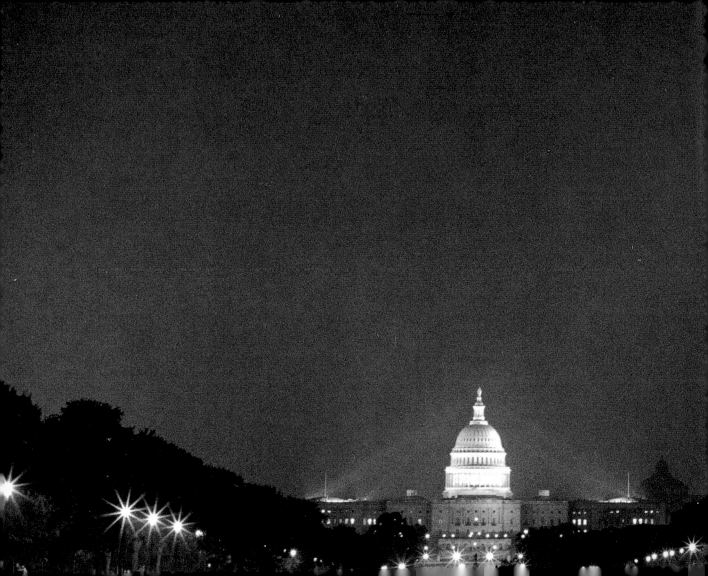

Although the Japanese cherry trees are Washington's most famous flora, there are well over 1,800 flowering plants and trees that are native to the District. Among them are several types of magnolia that flower well into the summer. These mature specimens were in bloom in June, 1923, when the immigrants from Japan had been here for just 11 years.

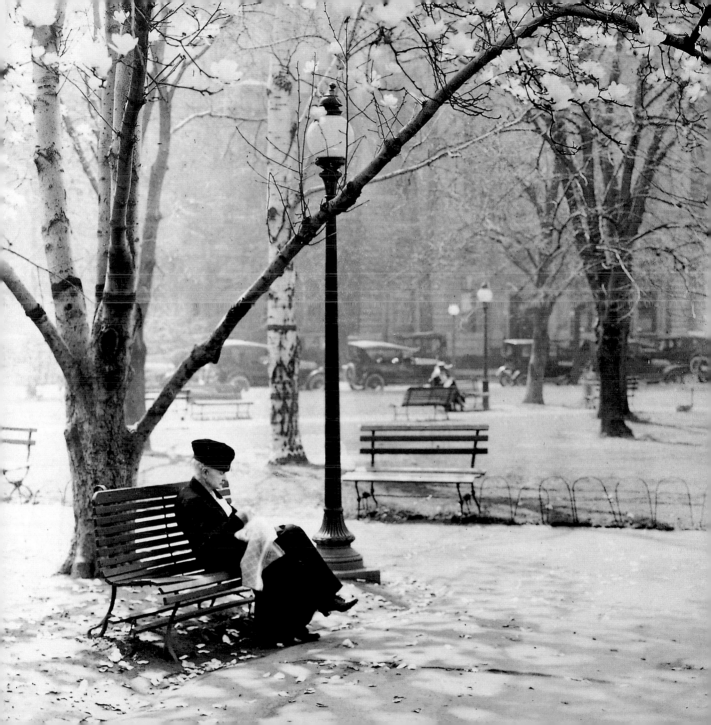

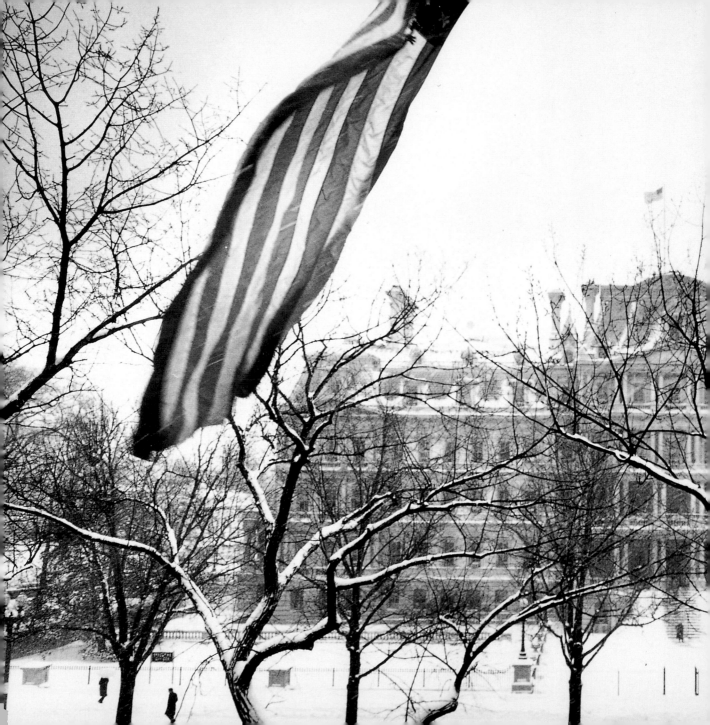

When the Executive Office Building was built in 1888 for the State, War and Navy Departments, it was the last word in architectural grandeur. Later, when it was suggested it ought to be demolished, President Harry S Truman, whose office had been there when he was vice president, put his foot down. "I don't want it torn down," he said. "It's the greatest monstrosity in America." Seen through the lens of Fred Maroon's camera, though, it doesn't seem *all* that monstrous.

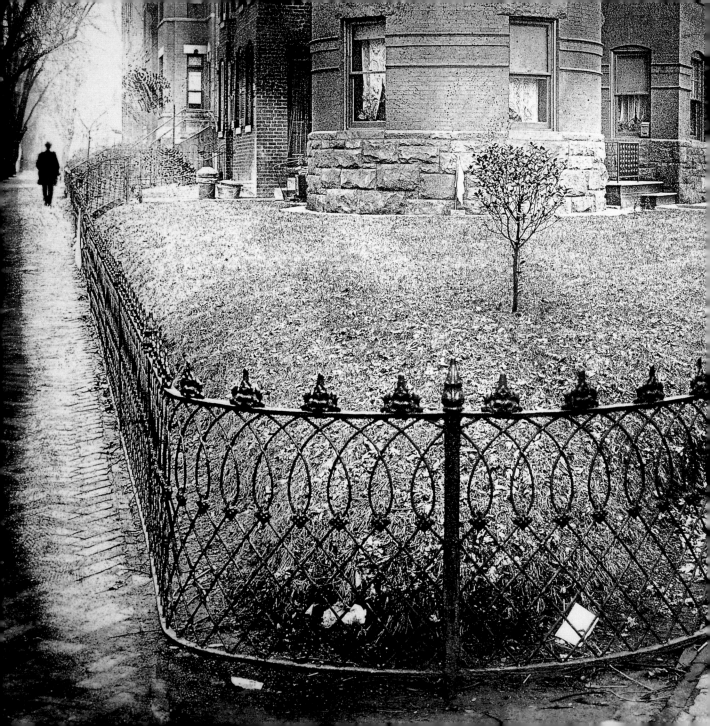

**When Alexander Shepherd
accepted the challenge to
remake Washington in**
1871, his paved streets
with sewer lines and water
mains under them started
a building boom. Row-
houses such as these grew
like weeds in neighbor-
hoods even the weeds had
rejected a few years ear-
lier. Many of them are still
there and still charming.
And the trees have grown
taller than the houses.

When it was decided that a memorial should be created to honor veterans of the Vietnam War, a national competition for a suitable design was won by a 21-year-old Yale architecture senior, Maya Ying Lin. She described her work as "a rift in the earth ... a long polished black stone wall emerging and receding into the earth." The wall is inscribed with 58,007 names in chronological order of death. In the years since the memorial was dedicated in 1982, visitors have brought their own memories and tributes to the wall, as Lloyd Wolf's photograph poignantly records.

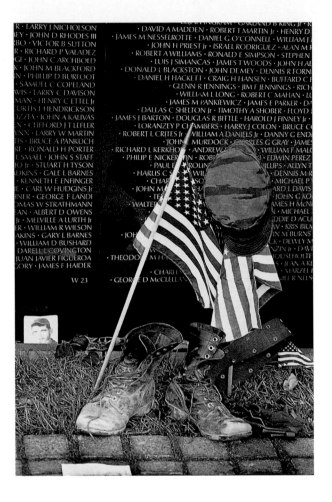

Facing page
The site of Arlington National Cemetery was confiscated from General Robert E. Lee in 1864 after bureaucrats determined he hadn't paid his property taxes. There are nearly a dozen burials a day there, and it is estimated that there will be no more space left when the century ends. Unless, of course, there is another tax delinquent in the neighborhood. Years after the seizure of Arlington, Lee's heirs sued the government for compensation for the mansion on the site, built by George Washington's adopted son, George Washington Parke Custis, who was Robert E. Lee's father-in-law. They were awarded $150,000.

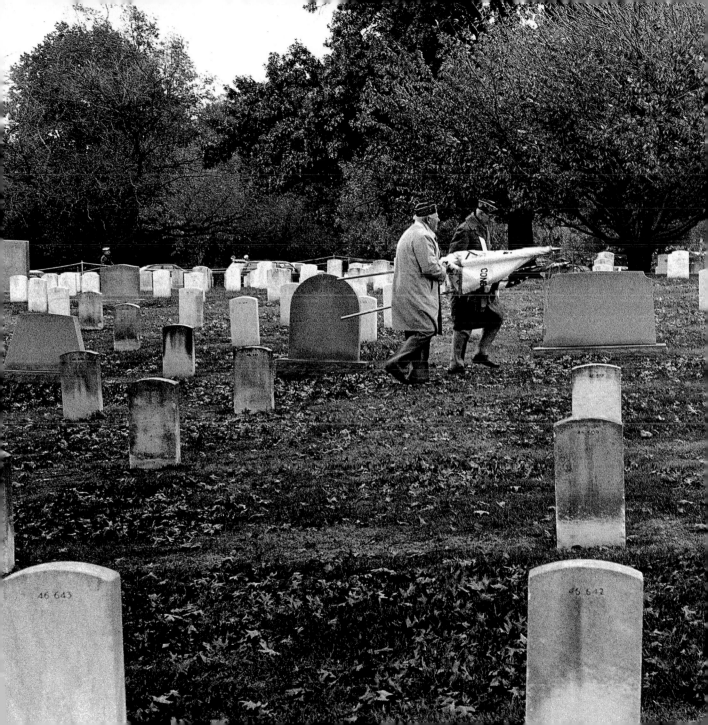

Arlington National Cemetery is the final resting place of more than 230,000 American heroes and their dependents, including Unknown Soldiers of World Wars I and II, as well as the Korean and Vietnam Wars. But only two American presidents are buried there: William Howard Taft and John F. Kennedy. The decision to make Arlington Kennedy's grave site was made by his widow in 1963, although others had been considered. Thirty-one years later, on May 23, 1994, Jacqueline Bouvier Kennedy Onassis was herself buried at his side.

Following pages
The Dupont Circle station on the Metro's Red Line was added in January, 1977, nine months after the system itself first opened. When it is finally completed in early 2001, the Metro will make 83 stops along a 103-mile route. Most of the stations will be served by escalators, including the longest one (at 230 feet) in the Western Hemisphere.

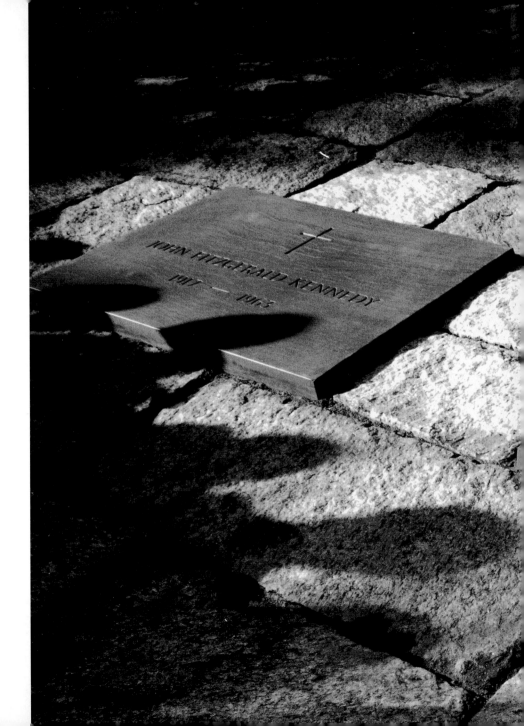

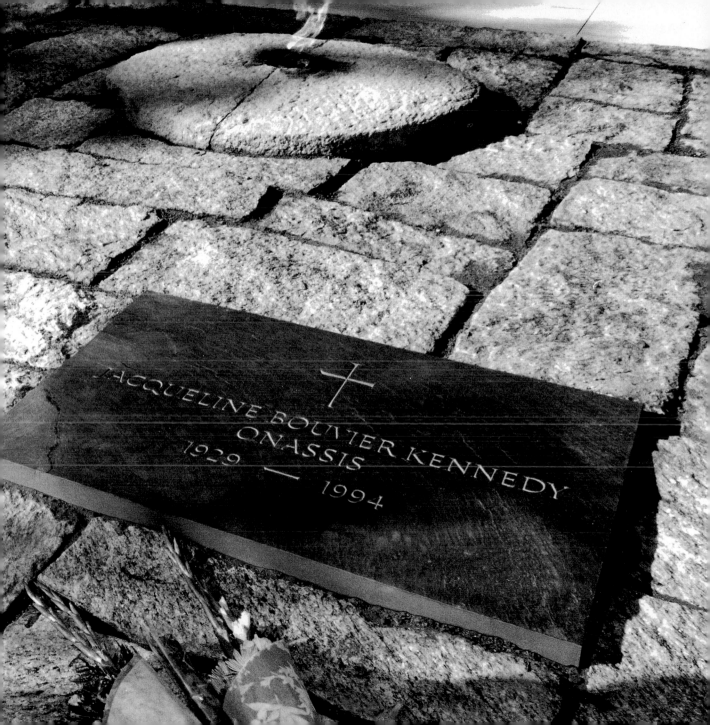

"Inside the Beltway" is an expression frequently used to describe the confines of the District of Columbia, but, actually, the combination of Routes 95 and 495 known as the Capital Beltway runs well outside the District's boundaries. The actual line, drawn in 1790 when the Maryland legislature agreed to give up nearly seven square miles and Virginia added another three, was marked by surveyors' monuments, such as this one discovered by Darrow Montgomery at the District's northwest corner.

CREDITS AND SOURCES